Postcard History Series

Chain O' Lakes

On the front cover: The Chain O' Lakes Region is well known for the abundance of lakes in the northwest section of Lake County, Illinois, and the eastern portion of McHenry County, Illinois. There are many channels, some natural and some dug by hand, that connect the 10 lakes considered the Fox Chain O' Lakes. Some of the channels were natural, carved out at the same time as the lakes during the glacier period, but some were actually dug during the beginning of the 1900s. Many were dug by hand. Low areas were made into channels so that the boats would have access to all the lakes. It was not unusual to see couples rowing through the channels, exploring the area and looking for wildlife along the shore. Although it is unknown which channel this is, the photographer definitely found a beautiful one to take this picture. (Courtesy of Ainsley Brook Wonderling.)

On the back cover: This is a view from O. W. Richardson's place on Channel Lake. The post date on the back of this card is April 3, 1907, and it is addressed to Fred Burrous in Ponca, Nebraska. The writer must have been having a grand time fishing. The lakes at that time were abundant with fish, and it was not unusual to have a morning catch of 20 or 30. The Richardson place, called Villa Bohemia, was a large establishment that could provide for several people. O. W. Richardson was the president of the firm of O. W. Richardson and Company, the large wholesale and retail carpet and rug house on Congress and Wabash Avenues in Chicago. He was a pioneer of the building on Channel Lake and surrounded his home with several cottages and picnic areas. This beautiful establishment was the place to be in the summer. (Courtesy of Art Doty.)

POSTCARD HISTORY SERIES

Chain O' Lakes

Wendy Maston and Robin J. Kessell

Copyright © 2006 by Wendy Maston and Robin J. Kessell
ISBN 0-7385-4039-0

Published by Arcadia Publishing
Charleston SC, Chicago IL, Portsmouth NH, San Francisco CA

Printed in the United States of America

Library of Congress Catalog Card Number: 2006924398

For all general information contact Arcadia Publishing at:
Telephone 843-853-2070
Fax 843-853-0044
E-mail sales@arcadiapublishing.com
For customer service and orders:
Toll-Free 1-888-313-2665

Visit us on the Internet at http://www.arcadiapublishing.com

*This book is dedicated to the memory of Robert Lindblad,
past president of the Lakes Region Historical Society and our Dad. He
helped maintain Antioch's history while giving us our own history.
Thanks, Dad.
We love you and miss you.*

Contents

Acknowledgments		6
Introduction		7
1.	Lake Catherine	11
2.	Channel Lake	17
3.	Lake Marie	31
4.	Bluff Lake	43
5.	Petite Lake	51
6.	Grass Lake	61
7.	Fox Lake and Nippersink Lake	79
8.	Pistakee Lake	91
9.	Loon Lake	97
10.	Other Lakes	109

Acknowledgments

The Lakes Region Historical Society was formed in 1973 by a few dedicated people who saw the history of the region slipping away. When the possibility became real that the society would be able to use and renovate the old schoolhouse that had been built in 1892, the membership gained momentum and the dream became a reality. In 1987, the Lakes Region Historical Society dedicated the new museum at Main Street and Depot Street in Antioch. The collections began in earnest.

Many of our sources are pamphlets that are part of the collections at the society. Many have no author, date, or even publisher. They were put together for advertising purposes during the early days of the resorts. They are being preserved for future generations.

All of the postcards came from the collection of the Lakes Region Historical Society, the personal collection of Art Doty, and the personal collections of Ainsley Brook Wonderling and her mother Janet Brook. Many of the cards were duplicates so we have not indicated from whose collection the individual cards came from.

We wish to thank all those people who have so patiently answered questions and provided information for this book. In addition to those above who provided the postcards are Marybeth Walsh, Charles Haling, John Haley, and Paul Jakstas.

A very special thanks goes to our mom, Dorothy Lindblad, whose stories, and most of all her encouragement, kept us going when things got tough.

Also to our families, without their support and patience this book would never have been done. Robin's husband, Thomas Kessell, and their daughters, Kristen and Gretchen, have been helpful when needed. Wendy's husband, Richard Maston, has missed many a meal, and their daughters, Patience Bertana and Robin Rhodes, had to put off talking to mom every day during the frantic writing period.

And one more thank-you goes to our editor, Jeff Ruetsche, whose encouragement and long e-mails help to keep us on track even through meltdowns.

INTRODUCTION

It is believed that the Chain O' Lakes were carved out of the land by the Wisconsin Glacier. Although the chain is usually considered to be made up of 10 lakes (Lake Catherine, Channel Lake, Grass Lake, Lake Marie, Fox Lake, Redhead, Bluff Lake, Petite Lake, Nippersink Lake, and Pistakee Lake), there are many smaller lakes in the area that are just as important. There are a total of 193 lakes and ponds in Lake County, Illinois.

Because the Fox River winds its way through the Chain O' Lakes, the chain is sometimes referred to as the Fox Chain O' Lakes. The Fox River begins its journey near Menomonee Falls, Wisconsin, and enters Illinois just south of Wilmot, Wisconsin, for a journey of almost 70 miles. It winds its way through the Chain O' Lakes State Park and flows into Grass Lake. From there it travels into Fox Lake, through Nippersink Lake, into Pistakee Lake where it leaves the chain and continues on its way in McHenry County, past Algonquin, and 115 miles farther into the Illinois River.

Prior to the mid-1600s, Native American tribes lived in the area and consisted of the Iroquois, Algonquin, Potawatomi, Mascouten, Sac, Fox, and the Miami. The Illiniwek Confederation was a political alliance among several tribes and gave Illinois its name. These peoples left many clues to their existence, but much of it was destroyed during the early 1900s when the area became "the spot" to build summer homes.

Prior to the early 1800s, there were no white men living within the bounds of what is now Lake County. Only the French traders made their way through this land. The land of beautiful clear lakes and an abundant supply of wildlife was the last area of the state to be ceded to the U.S. Government by the Potawatomi Indians. The area around the Chain O' Lakes was the last to be opened for settlement. White settlers began to quickly move into the area, and by 1840, many cabins had been erected in what is now Lake County.

Although many of the early settlers were farmers, they took advantage of the abundant wildlife. Many families hunted and fished for survival. As the families became more dependent on local agriculture, the hunting and fishing in the area became more of a recreation than a necessity. People from Chicago and the surrounding areas found the Chain O' Lakes to be a wonderful destination for vacations, especially in the summer months. Leaving the hot city to travel north was made easier by the arrival of the train. The first trains north of the city went into McHenry in 1854. By 1885, trains were making their way into Antioch and by 1900 into Fox Lake. This provided the much needed transportation to get to the lakes. Traveling by horse and buggy could take far too long, and those newfangled motorcars were not very comfortable. Some local families would open their homes to these visitors, and soon there was a need to erect larger lodgings to accommodate these families and individuals. The era of the resorts had begun.

Between the years 1908 and 1915, many channels were "cut" between the lakes so that boats could get from lake to lake. Some channels were actually dug by hand. Before this time it was not possible to travel through all the lakes. Some areas had small channels, but the new, larger boats could not get through. These channels truly made the lakes a chain.

A promotional book for the resorts in 1910 claimed that there were 37 resorts on the lakes. By 1919, there were over 130 different resorts. This was the heyday, but it came with a price. The year 1923 saw the early pollution of previously pristine lakes. There were so many resorts that the once quiet and serene location was lost. Resorts began to close as people began to buy land and build their own homes. Large tracks of land that had once been family farms were subdivided into lots and sold. By 1925, there were six new subdivisions in the area around the lakes.

The Chain O' Lakes has regained its popularity as a vacation destination in Northern Illinois. Many of the former summer homes of the people who first started vacationing here in the late 1800s and early 1900s have been converted to year-round homes. Many of these cabins were needed for permanent homes during the Depression years. Over the last few years, Lake County has exploded with buildings and homes. The growth rate is one of the fastest in the Midwest.

We had more than 1,000 postcards to look through to choose only 214 for this book. We hope that you enjoy our choices and invite you to visit the Lakes Region Historical Society in Antioch to see many of these images in person. The dates given are from the postmark on the back and may not be the actual date of the original picture.

MAP OF CHAIN. As an advertising program, Curt Teich of Chicago published a booklet of postcards of the Chain O' Lakes, and it was distributed by J. O. Stoll Company in Evanston, Illinois. It was a neat little packet that could be mailed. Inside were 16 artist renditions of some of the postcards that had been published by the same house. The copyright date on the souvenir folder is 1950. This drawing of the chain is the first one seen upon opening the folder. The map is not to scale and not totally correct but gives a great overview of the lakes. Many of the smaller lakes were known by different names in the late 1800s. And how some of the lakes got their names is still a mystery to many.

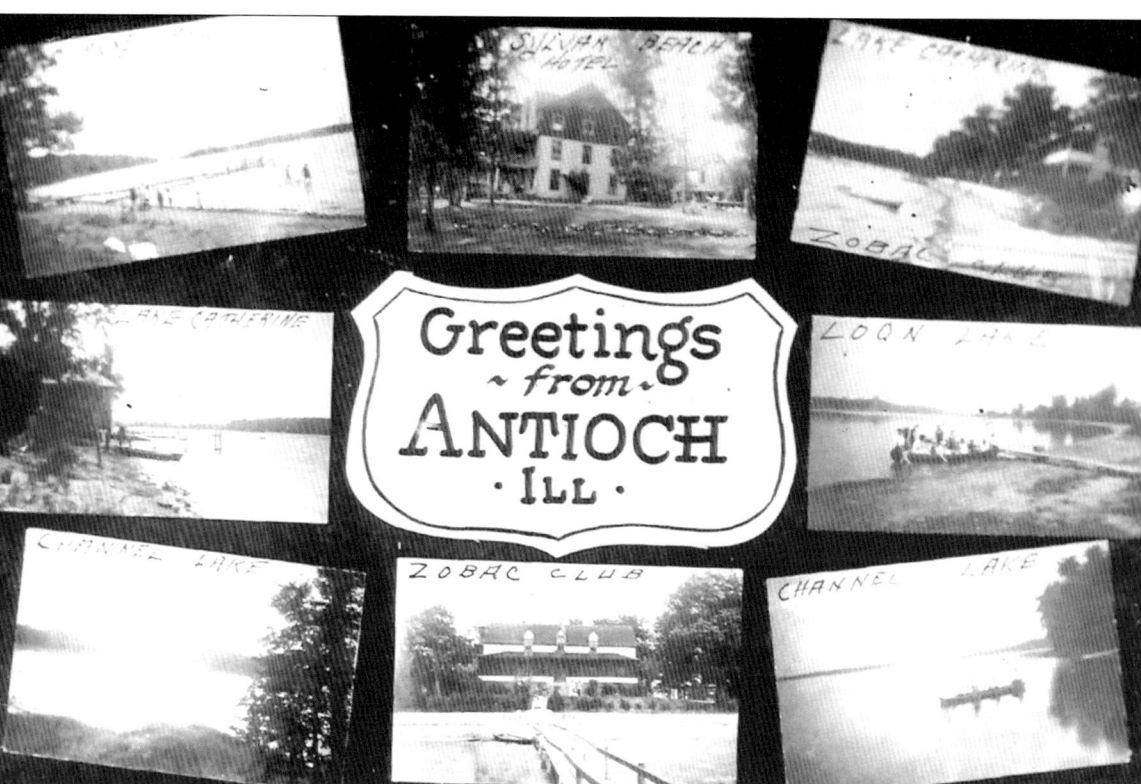

GREETINGS FROM ANTIOCH, ILLINOIS, 1910. Antioch has long been considered the beginning of the chain. This postcard is a montage of other cards from the 1890s. It was put together and printed by P. L. Huckins of Chicago. The images are from Lake Catherine, Channel Lake, and Loon Lake, the three lakes closest to Antioch. The Zobac Club was on Lake Catherine, and the Sylvan Beach Hotel was on Channel Lake. Both of these resorts are discussed later in this book. The long empty shorelines no longer exist. Homes were built along anywhere that the land would allow. These properties are the most desirable today.

One

LAKE CATHERINE

Lake Catherine is the northeastern lake in the Chain O' Lakes. It is considered the first lake in the chain and has a small inlet, Trevor Creek, on its northeast shore. A small lake of 155 acres, its depth can be up to 40 feet.

In the late 1800s, and into the early 1900s, there was a hotel in Antioch: The Simons House Hotel. The proprietor of this establishment was Ernest Simons. He ran a taxi service for visitors to get to the local resorts. He would hitch up the horses to his open buggy wagon and wait for the train to arrive at the station. Some of the guests would be dropped off at his hotel while others headed out to Lake Catherine and Channel Lake resorts.

Today the lake is surrounded with homes, and there are no resorts left. There are marinas where one can put in a boat for the day or rent a boat dock for the summer. There are also private beaches where only members have access. Many subdivisions developed around the lake as vacationers decided to make the area their permanent homes. Felter's Subdivision started before 1918. The property had been a family farm on the eastern shore of Lake Catherine. An early advertisement stated that the subdivision had 400 feet of park on shorefront. Lots were being sold for $500 and up, and the average size was 50 by 150 feet. Another advertisement for Warriner's Subdivision, just north of Felter's, stated that it was "a colony of comfy summer homes, no clubs, good roads, telephone and electric lights."

Another subdivision, Hillewood, was developed along a neck of land between Lake Catherine and Channel Lake, one and one-half miles from Antioch on the main road (believed to be Route 173.) The advertisement said, "The land is high and dry, and in the summer the cool air from both lakes makes it quite comfortable here." Its lots sold for $600 to $1,000 and were 50 by 200 feet. Mr. Hillebrand was the contact person.

Lake Catherine is a perfect lake for fishing, canoes, sailboats, and kayaks.

THE INLET, 1949. This small inlet is actually called the Trevor Channel. The two young boys who are happily rowing in this channel may be now teaching their own grandchildren how much fun it is to be on the water. Could there be a big bullfrog in those reeds? Surely their moms hope not.

SUNSET ON THE LAKE, 1936. What can be more beautiful than a sunset over a lake? The shadow trees and ceramic flower pots are silhouetted against the shimmer of the water. And who is that in the boat in the middle of the lake? Perhaps it is a young couple out for a moonlit ride.

FELTER'S COTTAGES. This stretch of cottages was one of the first to be built. The large track of land that is Felter's Subdivision once was a family farm. Located about a mile west of Antioch on Route 173, Felter's was home to the authors of this book. Many wonderful memories of childhood are cherished.

FELTER'S NORTH BEACH. Felter's is home to two beach parks. Residents often referred to this small, northern beach as "the little beach." At the time of this card, the area was not actually used for bathing. Even the horses were welcome. There were no docks yet, so people just pulled the boats onto the shore. These boats had no motors.

ZOBAK CLUB. The Zobak Club was made up of mainly butchers and saloon men of Chicago. This hotel was the only one on Lake Catherine. In 1906, with the intent to start an ice company through J. J. Morley, they were able to obtain the land and lake front to make this possible. Morley then sold the entire holdings to the California Ice Company of Chicago for $21,000.

ZOBAK'S CLUB HOUSE — LAKE CATHARINE
ANTIOCH ILLINOIS

LAKE Catharine is one of most beutifull of many lakes in Lake County. Best hunting, boating, swimming and fishing to be had here, bass, pickerel, pike anb other game fish here are plentifull. Lake Catharine is conected with Lake Channel, Marie, Grass, Fox and many other lakes which makes fishing a real pleasure. Fishing tackle always on hand. Rates are $1.50 per day, special rates per week and to families including best meals and use of boats. Distance is 55 miles from Chicago on the Soo Line. Trains leave Grand Central Station Fifth Ave. and Harrison St. at 2.15 and 8.50 A. M., 1.30 and 6.30 P. M., Sundays 2.15 and 8.05 A. M. 2.50 and 6.30 P. M.. Time 1 hour and 45 min. Bus will be waiting.

Phone 138 J. Antioch Ill.

JOHN VLCEK, Manager

ZOBAK CLUB ADVERTISEMENT. This is the reverse of the above card. The card was used for advertising and even gave the times of the trains from Chicago. It took 1 hour and 45 minutes, but today's schedule from Antioch to Chicago takes 1 hour and 35 minutes. Not a lot of progress! However, today's commuter train stops at many more stations than in the early 1900s.

SCHUMACHER'S PLACE. These beautiful homes on the lakefront were early summer homes and opened to friends and relatives from the city. Eventually they were renovated to be year-round. Most had to have electricity added as well as bathroom facilities. Some added insulation, but many of these homes were very drafty.

HENRIKSEN'S BOATHOUSE. Boathouses were a sign of wealth, as they were built to house the expensive boats. Looking closely one can see the back boat has an inboard motor. One of these boats today would be worth many thousands of dollars. The boat would be stored for the winter, hopefully keeping the animals from using it as shelter. The second story would be a party room for summer festivities.

A GLIMPSE OF CERMAK SUBDIVISION, 1929. Cermak Subdivision was at the south end of the lake and accessed from Route 173. This is a perfect example of changing cards. In 1925, a card similar to this one did not have a name on the boat. Perhaps someone wanted to impress a sweetheart!

THE POINT, 1909. This point of land divides Lake Catherine from Channel Lake. In later years it would become a sandbar where boaters could anchor their boats and get out to swim in shallow, sandy-bottom waters. On the back of this card, a young man writes home to tell of the 27 blue gills he caught that day—June 15, 1909.

Two

CHANNEL LAKE

Channel Lake is directly west of Lake Catherine. It is more than double the size of Lake Catherine, with over 353 acres. Its deepest point is approximately 42 feet deep. It was a lake of many resorts. The more popular resorts are mentioned here, but there were more over the years. Many marinas can be found around the lake today, but the hotels are gone. Many of the hotels and cottages became permanent homes or were torn down for progress.

The original road running west from Antioch followed a different path than Route 173 today. That dirt road is actually still there and is an asphalt subdivision road. Traveling west, the road went over the channel between Channel Lake and Lake Marie, farther north than the present bridge. It then passed north of Smith's Hotel, Cox's Store, and Gifford's Hotel before heading on west so that the road would pass in front of the hotels' main entrances. As it was only a dirt road, it does not often show in the postcards. As the road became busier with traffic after the introduction of the automobile, the road was moved south so as not to disturb the guests of the hotels.

From the *Antioch News*, June 28, 1906:

> Channel Lake Water Carnival. Elaborate plans being made. The Water Carnival, which proved such a success last year, will be given in early August. The races and sports of all description will take place in the afternoon while the evening will be given to music, dances, and a grand display of fireworks, and yacht launches and row boats will be decorated with Japanese lanterns, which is one of the grandest sights for an evening display that can be imagined.

The lake is surrounded with bluffs and many a home was built far above the actual shoreline. The mostly sandy bottom at that time was home to dozens of varieties of fish and made for some of the best fishing on the chain. Because of this and the great bathing beaches, Channel Lake became one of the more popular lakes to visit.

CHANNEL LAKE BRIDGE, 1909. This bridge connected Channel Lake to Lake Marie and was the road now known as Route 173. Webb's Marina is located on the southwest side of the channel. There is a smaller bridge farther west that also crosses a small channel connecting the two lakes.

SMITH'S LAKE VIEW HOUSE. Owned and operated by Dr. H. A. Smith and his wife, this beautiful hotel was the place to stay. Only two blocks from the new $50,000 dancing pavilion, patrons had every possible amenity. Swimming at a sandy beach and fishing from the free boats and then dancing the night away—what more could anyone want? Rates were $3.50 per day, $16 per week in June, and $18 per week in July and August.

NEAR SMITH'S BATHING BEACH. What a delightful view. A fallen tree to sit upon, to gaze out on the lake, what could the lady be thinking? Is she hoping for a long night at the dancing pavilion or perhaps a quiet evening at the hotel? Is this her beau? These questions can never be answered.

SMITH'S BOAT LANDING, 1938. Those who stayed at Smith's could access their boats from a modern pier. No need to have to step in the water to push the boat away from the shore. Even though the postmark date is 1938, the picture is earlier. The note on the back is quite interesting. It is written to Molly Flook from Gene Smith and says, "This is where I was born."

SAVAGE'S PAVILION, 1921. Near Smith's was Savage's Pavilion. A popular place for amusement, it offered a variety of choices. It included a bowling alley, ice cream, candy, soft drinks, and cigars. All variety of watercraft could be taken care of here, from canoes to gasoline motors. And every evening saw the gaiety of the dance and music.

GIFFORD'S HOTEL, 1912. One of the most beautiful hotels along the shores of Channel Lake was the Gifford Hotel. It is one of the oldest hotels on the lake and guests returned here year after year to enjoy the hospitality and good food. Mrs. F. E. Fenderson and her husband are the proprietors, and she is well known for her wonderful gardens and fresh vegetables.

THE DINING ROOM, 1921. A separate building on the grounds, the dining room was a place to meet everyone. Those who stayed in the main house and the various cottages would gather at dinnertime for those wonderful meals and to share the day's events.

GIFFORD'S LAWN AND SHORELINE, 1909. The hotel was on the south shore of the lake, and guests could see the entire length of the lake. The visitors to this establishment were the more privileged. They had access to a golf course, private dancing hall, and tennis.

VILLA BOHEMIA. The palatial residence of O. W. Richard, this home was open to some of the wealthier of the Chicago residents. Through the warm summer months, friends and relatives would come north for the cool summer breezes and the hospitality of the Richard family. Richard had a steamboat that would accommodate up to 75 for tours of the lake.

LADIES OF THE DAY, 1906. Clara and her friend strolled along the shoreline of Channel Lake. Perhaps they were waiting for one of the steamboat rides or a "chafing dish" party at the villa. Richard also built many cottages surrounding the villa for his guests.

CANOES ON THE LAKE, 1913. These ladies were spending a quiet afternoon paddling across the lake. This was one way that ladies could get exercise. They would go back to the hotel to take a nap before an exciting evening at the dance pavilion. Note the houseboat gliding across the water in the background.

EUGENE COX'S BOAT LANDING. The boat landing was a small part of the Cox's Store. Eugene Cox provided the conveniences for the vacationers in the area. This up-to-date store carried a complete line of groceries, hardware, automobile parts, fishing tackle, and fresh fruits and vegetables. He also had a gasoline station for the new cars and a McClellan refrigerating system to keep food cold and provide for the soda fountain.

CHANNEL LAKE PAVILION. The pavilion was reported to be the best entertainment in the entire area. An advertisement in an early book about the chain said, "Greatest Line of attractions under any one roof—our friends advertise us, 'Nuff said.' Open continuously from June 21 till Labor Day. Dancing every night. Searchlight will guide the way. W. O. Winch, President."

SUMMER HOME. This is a fine example of a 1930s summer home. The white picket fence and the birdhouse high in the air gave this little country cottage the feeling of security and contentment. Homes such as this quickly became year-round homes as the population of the area continued to grow.

MASON'S COTTAGE. The party is here. What a joyous time these young people must have had. This cottage was built into the side of the bluff. All around the lake the high ground was evident. When the glacier carved out the lakes it pushed the land up along the banks. What appears to be a third floor was actually the first floor on the road side.

SAILING, 1906. A popular pastime for the elite in the early 1900s was yachting on the lakes. Sailboats could be seen skimming along the water at very fast speeds. Racing was a great sport, especially in the hot August weather. The boats would be seen from early in the morning until the last rays of the sun.

VETANAS SYLVAN BEACH HOTEL VERANDA, 1908. On the veranda, the ladies could sit and enjoy the cool breezes. Many rocking chairs line the length of the hotel, and these ladies have gathered around a table. The ladies could be having a rousing game of cards. Obviously this picture was taken for the ladies, as the card was sent to Edna who returned it to Estelle with the writing on the front.

WATSON'S SYLVAN BEACH HOTEL—OLD MONARCH, 1908. This beautiful old tree was probably very old in 1908. It looks like Old Monarch was at least 100 feet tall. The gentleman at the base is dwarfed by the tree. It would be interesting to see if it still survives.

RICHARDSON'S SYLVAN BEACH HOTEL, 1914. The hotel was located in the beautiful Sylvan Woods on the north side of Channel Lake. Most of the area was owned by the Williams brothers, E. B. and D. H. They were well-known merchants in the Antioch area in their day, and the building constructed for their business still stands in downtown Antioch today.

ROTH'S SYLVAN BEACH BOAT LANDING, 1925. Roth was perhaps the last owner of the hotel. This card shows the long pier that extends far out into the lake. The bathing beach was reported to have a sandy bottom for 500 feet from the shore. From this view one can see the south side of Channel Lake where Gifford's Hotel was located.

SUNNY BANKS RESORT. This resort's earlier advertising postcard was an artist drawing depicting the beauty of the resort. In the early days, they advertised "modern housekeeping cottages" and "private beach and grounds." As the years passed, the owners, John and Jean Horsch, added marine service and boat stalls. A favorite stop was "the Ship." This unique building was a soda fountain and grill to feed the hungry guests.

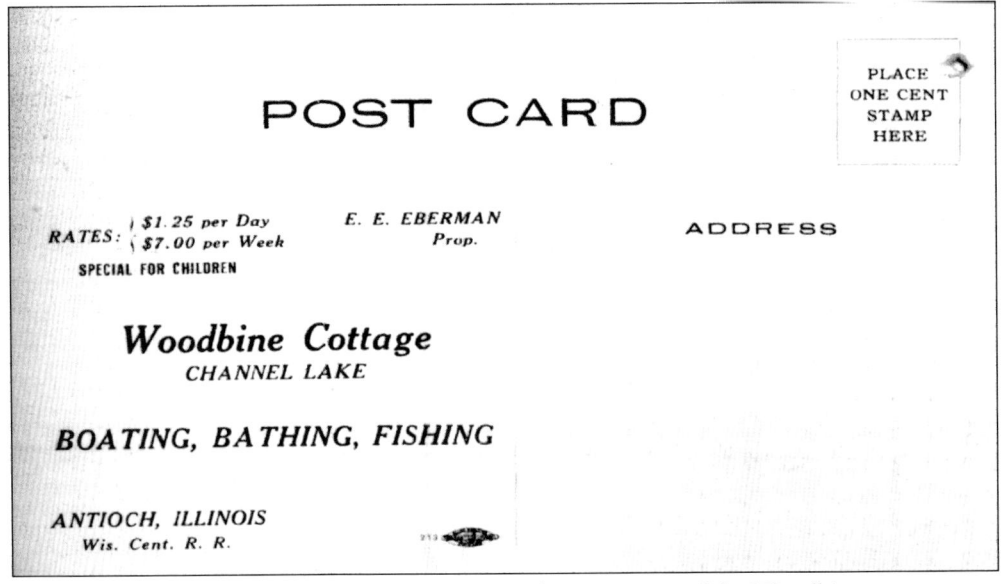

ADVERTISEMENT FOR WOODBINE COTTAGES. The proprietor of the Woodbine cottages was E. E. Eberman, a well-known name in the area. An effective form of advertising was to put information on the back of a postcard. Guests could take one home for later use, or one could be mailed to prospective customers. Rates were very competitive.

THE SUNSET VILLA, 1908. These people were probably German, as the message on the back of the card just says, "The cottage is the Bismark." Because of the date, the sender of the postcard may have been referring to Prince Otto von Bismark of Germany (1815–1898). He was responsible for the unification of several states into Germany. He lived lavishly, and so the reference to the cottage could have meant that it was grand.

THE WOODCREST CHANNEL, 1945. The cottages around this channel are part of the Woodcrest Subdivision. Many homes were built after World War II, when the soldiers and sailors returned home and needed housing. The west end of the lake was home to this subdivision.

VIEW OF LAKE MARIE FROM SMITH'S HILL, 1917. When the photographer took this picture he was standing with his back to Channel Lake. Eventually Route 173 would pass through the middle of this view and it would be filled with homes, businesses, and lots of traffic.

H. B. SMITH'S REFRESHMENT PARLOR. When the time came to head home, the last stop would be the Refreshment Parlor. Here one could get soft drinks, tea, snacks, and whatever else one might need for the ride back to the city. The local people also used the store for a quick respite from the busy weekend.

Three

LAKE MARIE

The third lake in the chain, Lake Marie is the largest so far. It has approximately 480 acres and is only 36 feet at its deepest point. It has three inlets: the two channels mentioned in the last chapter and the inlet point of Sequoit Creek on the northeast side. Today, Route 173 separates Lake Marie from the upper lakes: Lake Catherine and Channel Lake. The lake also stretches east to Route 59 and south to Beach Grove Road. It has two outlets, one into Lake Bluff via the small Spring Lake and the other into Grass Lake.

Lake Marie is one of the more beautiful lakes in the chain. Even today it is a fairly quiet lake most of the time. The Fox River does not flow directly through this lake or Lake Catherine and Channel Lake. This keeps all three lakes quieter than the rest of the chain. On a clear morning, the sun rising over the lake is truly a breathtaking sight. The still lake reflects the sun in perfection.

The resorts that lined the shores in the early 1900s were many. From the oldest resort, the Toby Inn (1870), to the Shady Nook, Dressel House, and Cobb's Resort, they all played a part in the development of the surrounding area and the new town of Antioch. The other lakes flowing southward would be instrumental in the growth of other towns, but these three were the lifeblood of Antioch.

THE SHADY NOOK HOTEL. The Shady Nook Hotel was located on the west side of Lake Marie and had several individual cottages. It was three miles from Antioch and was accessible by the same dirt road that took guests to the south side of the Channel Lake resorts. The Shady Nook is no longer, and in its place stands a large private home.

THE SHADY NOOK COTTAGES, 1932. The writing on the reverse of this card reads, "6-17-32 Dear Mother, Arrived here O.K. at Shady Nook yesterday afternoon and find it a lovely place belonging to Ben Seyfarth. Was in Bathing yesterday and got sun burnt also was fishing caught some nice ones 9 inch long. Will be back soon. As ever, Ollie and the girls."

THE LIGHTHOUSE OF LAKE MARIE, 1941. The back of this card explains where the lighthouse is. "Thur. morn. Dear Dad and all. This is a picture of the light house on Esther's sister's lake home. They built it. That's where we were last Sunday. Please keep this for me."

VENN'S ISLAND. Venn Island is in the center of the upper part of Lake Marie. Although this is a small island there is one home on it today. The west side of the island was very marshy and not total water. The owner was able to put in a small road to get to the island. It is private.

MEHRING'S RESORT. The Mehring Resort was located on the east shore of Lake Marie. This card was used as an advertisement. Printed on the back, it reads, "Home cooked dinners and home made bread, rolls, and pastries. Dining room available for Weddings, Parties, and Banquets. Choice Liquors. Rooms, Cottages, and Pier space available. Paul and Rose Mehring, Route 59 and Beach Grove Road. Phone Antioch 730."

CALIFORNIA SUBDIVISION, 1928. The California Ice and Coal Company owned the property along the south side of Route 173, across the highway from Felter's Subdivision and on the north shore of Lake Marie. The subdivision was laid out in a grid and started at the east end with First Avenue and ends with Seventh Avenue. One advertisement said that lots were 50 feet by 100 feet, cost $600 and up, and there were cement roads all the way from Chicago.

TOBY'S INN, 1908. The reverse side of this card has only the address. It was addressed to J. P. Arnold in Colfax, Illinois. It was amazing that mail could be delivered with only a town and state. Many of the cards had such addresses and were mailed off in great faith.

TOBY'S INN, 1909. The Toby Inn is reported to be the first inn to open in the area, around 1870. The actual inn remained in service until 1976, although it changed owners and name in the 1920s. It was situated on Merrywood Point on the east side of Lake Marie.

WURZ'N SEPP'S. Joseph Fallbacher changed the name of the Toby Inn when he purchased the resort. Wurz'n Sepp's became as well known as the Toby Inn had been and continued the fine service for which the Toby Inn had become famous. It advertised a "German Kitchen."

WURZ'N SEPP'S, DINING ROOM. This bright and cheery room overlooked the lake and provided diners with a delightful view. The open windows allowed the cool breeze to flow through the entire building. The kitchen provided authentic German food that satisfied the palate of the most demanding patron.

BAVARIAN COTTAGE, WURZ'N SEPP'S LAKE MARIE RESORT, ANTIOCH, ILL.

BAVARIAN COTTAGE. These wonderful cottages gave the guests a feeling of being in the Alps. Each cottage could house an entire family for the week or the whole summer. One of these cottages is now home to a local resident.

Club Der Gemutlichen Schwaben Lake Marie, Antioch, Ill.

CLUB DER GEMUTLICHEN SCHWABEN. With a large German population that enjoyed the area around the Chain O' Lakes, it was inevitable that they would have their own club. This card was the sample made up as an advertisement by Curt Teich of Chicago. The authors hope they did not use it, as the map on the back had several mistakes.

37

DRESSEL'S RESORT, 1917. The Dressel House was located on the southeast shore of Lake Marie. The homelike surroundings and home cooking would bring almost everyone back for more. The house catered to first-class families. Mr. Dressel also had an agency for Evinrude Motors. He sold motors and rented and repaired them, as well as boats and canoes.

TENNIS COURTS. There were tennis courts and a baseball diamond close to the main house at the Dressel Resort. Many an afternoon was spent either playing or watching a game. Perhaps a gentleman would spend the morning fishing on the lake. After a hearty lunch and a quiet hour sitting on the lawn, a game of baseball might be played while the ladies looked on.

COTTAGE AT DRESSEL'S LAKE MARIE ANTIOCH ILL

THE COTTAGES. The rooms in the main house as well as the several cottages surrounding the house would accommodate 60 people. Each cottage could house an entire family. Sometimes the family would rent a cottage for a month or more, and the wife and children would stay at the cottage while the father had to return to the city for work and would come out on the weekends.

Looking West Towards Dressels, Antioch, Ill.

LOOKING WEST. Although the card says "Looking West Towards Dressels," this could not be correct. Since the resort sat on the southeast shore of Lake Marie, no one would be able to look west to see it from the lake. The text on some cards can be incorrect because the photographer or printer might have had wrong information.

39

SAILING, 1914. One of the most delightful pastimes on the lakes during the summer was sailing. The calm waters of Lake Marie made it perfect for the sailboat. This boat, however, appears to be a bit overloaded. Sailing on the lakes today is not quite as easy because of the large numbers of motorboats, but an occasional sail can still be seen gliding across the lakes.

COBB'S COTTAGES AND CAMPING GROUNDS ON LAKE MARIE NEAR ANTIOCH, ILL.

COBB'S COTTAGES AND CAMPING GROUNDS. Cobb's could fulfill almost any need for vacationing. With cottages as well as a beautiful camping area, anyone could find a comfortable spot. The cottages were nestled in between the tall trees, and tenting areas were close by.

COBB'S ICE CREAM PARLOR. The sign on the pole announced to anyone in the area that this was an ice-cream parlor. Those who might have been out rowing could stop for a special treat. It was not easy to keep the ice cream frozen, so it had to be eaten fast.

COBB'S BATHING BEACH. With this wide view one can see the open spaces behind Cobb's. The bathers had to share the beach with the boaters. This early resort was one of the first built on the lake.

TRINITY CHOIR CAMP, 1909. The message on back of card reads, "Dear Sis. I am in town shopping, getting more grub for next week. Write me a letter with R. F. D. No. 1. Love, Clara." This card was a picture taken by Lugar. He used the basic photograph and made cards for each camp that came through. It is doubtful that this camp was in session when the author wrote it, as the post date was April 17, 1909.

MILLS HOME. The Mills Home was located at the west end of Beach Grove Road, under the arch. According to the directions handwritten on the back, it was the house with the Duisenberg cars. It had this lovely flower garden with a fountain in the center. Many of these large homes still exist under the arch.

Four

Bluff Lake

Bluff Lake is one of the smaller lakes, with only 86 acres. It has a depth of approximately 40 feet. Its inlet is only Lake Marie on the northwestern side, and it flows into Spring Lake on the southeast side. It is considered an excellent lake for fishing and can be accessed by Steitz's Resort on Grass Lake Road.

The following paragraph is quoted from a early 1900 advertising booklet. The booklet has no date, no explanation as to who had it printed or any identification. It is thought that it was done by the resort owners themselves. The booklet is page after page of resorts and descriptions, prices, and so on. The booklet is in the Antioch Archive section of the Antioch Public Library District.

> Bluff Lake is situated four miles west of Antioch and is frequently spoken of as the most beautiful lake in the entire chain. Wooded bluffs with their mossy green slopes form a most fitting background for this magnificent picture, designed by Mother Nature herself. Here and there boats dot the quiet surface of the lake, and the many cottages which line the shores give a true evidence of the life and activity of the summer season.

Bluff Lake had many smaller resorts, but only a few are mentioned here. One of the resorts still in business today, after more than a century, is Steitz's Resort. Although it started as a hunting and fishing resort, today it is well known for its restaurant, bar, and marina services. Open year round, they have recreational vehicle rental sites. There may no longer be cottages to rent, so just bring your own. It is one of the oldest remaining family-run businesses on the chain.

But the very best story that Bluff Lake can lay claim to is this: Bugs Moran was taken into custody at a Bluff Lake resort. Fact or Fiction?

ROAD TO HERMAN'S. Herman's Bluff Lake Resort was one of the biggest on the lake. There was space for over 100 guests. They would travel over this winding road and find the large hotel at the end. Many of the dirt roads ended at a resort. These trees must have been spectacular in the fall. The original farmhouse was built around 1859.

A VIEW OF BLUFF LAKE, 1904. These unusual boats were some of the first to be used for touring the lotus beds. They could not carry many passengers but could get closer to the lotus beds. The view across the lake to the other side shows that there is very little over there, only another resort.

THE CHICKEN COOP, 1915. This should have been named "the duck pen" because of the ducks on the top. These 12 people were probably from the same family and wanted to have their picture taken for a memento of their summer vacation. The boats in the background were the boats that took the visitors out to the beds.

Chas. Herman's Cottage, Bluff Lake, Ill.

CHARLES HERMAN'S COTTAGE, 1908. This small cottage on the hill may have been the early beginnings of what was to become one of the most popular resorts. Herman's continued in business until 1959, when James Carroll and his wife purchased it all. The 100-year-old hotel was torn down in preparation for a new, modern, super resort. The new resort was to be in conjunction with George Diamond's Restaurant near the corner of Route 59 and Grass Lake Road. The resort never happened. And Herman's was gone.

JURCHIK'S RESORT. John Jurchik was considered a new comer but was doing a good job. Once patrons had been to his place, they encouraged their friends to follow. This house was most likely a farmhouse before being converted to a resort.

JURCHIK'S LAKEFRONT. The house from the previous picture can be seen if one looks closely. The fellows in the pictures were posing for the photographer, who was in a boat. Imagine how hard it was for him to take this picture. Even today, trying to take a picture from a boat is difficult!

JOHNSON'S PIER. This group of people was no doubt waiting for the tour boat to take them to the lotus beds. Or maybe they are just waiting for the flash from Lugar's camera. Lugar lived in the Antioch area for many years at the beginning of the 1900s and took many pictures of all the resorts. He would find even the smallest resort and offer his services.

A COUNTRY HOUSE, 1927. This house was the utmost in luxury. The landscaping is one of the first efforts of man to change the natural look of the land. Most of the resorts would work around nature and build within the trees. Here most of the trees have been removed and the natural bluff has been terraced. Also, the stones along the shoreline represent an early seawall.

THE ECHO CLUB. This small club sat high on one of the bluffs that overlooked Bluff Lake. This is the side that faced away from the lake. This side of the house had only two levels while the lake side had three.

THE ECHO HOUSE AND CASSIDY'S BLUFF LAKE RESORT, 1925. This lake view shows the lake side of the Echo House (center). Here one can see the third level. Cassidy's is right next to it and has one of the dance pavilions that were so popular. The natural bluffs would rise and fall along the shore.

SAVAGE'S STORE. This is a great example of how a family could fit with the resorts but not have all the work that went with overnight guests. The Savage's added on a room to their house and opened a little store where people could get several items needed for camping, fishing, and other activities. They surely would have had a candy jar!

CHRISTIE WHALENS BLUFF LAKE HOTEL, 1951. Look closely at the hotel on this card and the one of the Echo House in 1925. The rooms in 1951 were $15 per week per couple. The same rooms were only $2 in 1925. The directions that were given were to take 45, 12, and 59 to Nielson's Corner (now the corner of 59 and Grass Lake Road.) Or take Cardinal Bus Line to Nielson's Corners and call for a pick-up.

CHESHIRE AND KEPNER. This one was reported to be one of the neatest, well kept, and immaculate resorts on the chain. The good management was credited with the success of this resort. The hotel sat high on the hill for the best view and rooms were $2.50 per night.

BLUFFDALE RESORT. Bluffdale is the same resort as above. This view shows a group of guests enjoying a beautiful summer day on the lawn. A child's swing has been hung from the tree, and Momma is giving her child a ride.

Five

Petite Lake

Petite Lake is one of the smaller lakes, only a little bit larger than Lake Catherine and almost twice the size of Bluff Lake, at 167 acres. Its median depth is 22 feet. Its inlet is a channel from Spring Lake on the northwest corner. Its outlet is to Fox Lake on the southwest corner. This lake is a great lake for fishing, with walleye, muskie, and largemouth bass in abundance.

In an advertising booklet, the following described the lake:

> Petite lake, four miles from Antioch, in a southwesterly direction, is noted for the grandeur of its setting, its mirror-like surface reflecting the manifold beauties of its shores and islands, and the wonderful fish which are taken in abundance from its cool depths. . . . A vacation spent in this place will be a never forgotten epoch in the history of your life.

Petite Lake was home to two of the finest resorts in the area. The Simons Hotel, which started as the Petite Lake Hotel, became well known for it excellent hunting and fishing excursions. It became the Simons Hotel because the owner was I. Simons, and people just referred to it as the Simons place.

The Queen of the West was a popular hotel being one of the largest at the time. One description of the Queen of the West said that it had velvety green lawns, a wide veranda, and well-kept boats. It also boasted of one of the finest dance pavilions in the area.

PETITE LAKE HOTEL, 1909. I. Simons was the proprietor of this popular hotel. It would eventually be referred to as the Simons Hotel. Simons was a "local" and knew the secrets of hunting and fishing in the chain area. A wonderful quote from an early booklet said, "These secrets he freely shares with his guests, thus enabling them to become the possessors of some most enviable strings of the finny tribe and bags of game."

SIMONS HOTEL FROM THE LAKE, 1911. As with many of the lakes, the banks are sloped and the buildings sit high above the water. The staggered steps were welcomed by the guests and made it much easier to get down to the boats. Standing at the top of the steps and looking across the lake was indeed a beautiful site.

SIMONS HOTEL BUS LANDING, 1912. Simons provided the best for his guests. The road came directly to the hotel and had a turnaround so that the horse-drawn buses could pull right up to the landing. Guests could easily step from the bus onto the wooden platform. Ladies did not have to worry about getting their dresses dirty.

SIMONS HOTEL AND COTTAGES. The hotel is on the right side of the picture, and one of the cottages is to the left. The bus landing can be seen at the center.

VIEW OF PETITE LAKE FROM SIMONS HOTEL. Lugar had an eye for great shots. He could find the most beautiful scenery and save it for eternity. Looking across the lake, one can see the rolling hills that surround the lake. Imagine an afternoon just sitting and enjoying the cool breezes on a hot day.

PETITE LAKE HOTEL. This is an early picture of the hotel and shows the difference in quality from Lugar's photographs. This card was commissioned by James H. Swan, the druggist in Antioch, and was probably sold in his store. Many of these cards were actually printed in Germany.

PETITE LAKE PARK, 1936. As the subdivision began to take over popularity from the resorts, many of them set aside a portion of land, with shoreline, for a subdivision park. The park would only be available to residents of the subdivision. Usually the people would form an association and pay dues each year to help with the upkeep of the park. Even if one was not directly on the lake, one would have access to the water.

COMMUNITY HOUSE. Some of the subdivisions, or many together, would build a community house that could be shared by everyone. A family could rent the community house for large events. Even weddings could be held at such a place. They may have rented out rooms in order to help pay the expenses. The subdivisions would come together as a little town.

QUEEN OF THE WEST. One of the earlier and largest hotels, the Queen of the West was built as a hotel and did not start out as a home. The proprietor, Ned Bates, welcomed guests to the well-equipped hotel. Note the horse-drawn bus and the trees in the front of the hotel.

QUEEN OF THE WEST, 1922. This is another view of the same hotel but a few years later. So much is the same, as the popularity of the location continued to thrive. However, note the trees—they have grown considerably, and instead of the horse and buggy guests now arrive by automobile. This view also shows a water tower in the back to provide guests the very best of amenities.

QUEEN OF THE WEST, 1907. This view of the Queen of the West is in its early days. The lake shore was still very much the way it had been for hundreds of years. It must have been a very windy day this shot was taken, as the grasses were waving. The writer of this card was complaining because it was too cool in August to go swimming.

QUEEN OF THE WEST SHORELINE. This is a much later view of the Queen of the West from the lake. The shoreline has been improved to make it easier for guests, and a tour boat is pulling up to the pier to pick up passengers for the trip to the lotus beds and Blarney's Island. The writer of this card stated that their fishing group had caught 121 fish that day, and they would be having some for supper.

ST. JOSEPH CAMP. This shot of Camp St. Joseph may look familiar. The card is dated 1936 although the picture is a little earlier. It is the same building and bus landing from the Simons Hotel. After the heyday of the resorts, this property became a camp for young people.

TERRACE AT ST. JOSEPH. One can see the improvements that had been made at the old Simons Hotel. The land had been terraced, and a seawall had been put in. This beautiful property is an example of how people felt about the lakes.

PINE LODGE. A. Shostak and Son's Pine Lodge was one resort that continued in business past the time of the other resorts. One can see the cars are more modern, and advertising a cocktail bar would not have been possible in the 1920s.

BLUNT'S POINT, 1929. The scene shows how wide open the space really was. The mirror image on the lake was more common, as Petite Lake is well protected and off the main track of the chain. Today many homes line most shores. There is very little buildable real estate left anywhere on the chain.

POEM, 1916. What a fun postcard. This is another way of advertising to get people to come to the area either to vacation or live. The small picture of the view of Petite Lake from Simon's lawn is an earlier one taken by the same company. Petite Lake was considered one of the better places to visit.

*IF you are looking for a
 classy town
You need not farther
 roam
Just pack your grip and
 come at once
And make this place
 your home.*

THE CHANNEL. This was the channel that connected Petite Lake to Fox Lake. The drawbridge had to be raised for even a rowboat or canoe to get under. This problem has been resolved, and it is easier today to get from Petite Lake to Fox Lake. The only other way was to travel back through Bluff Lake to Lake Marie to Grass Lake to Fox Lake. It was a rather long trip.

Six

GRASS LAKE

Grass Lake is the third largest lake in the chain, with only Fox Lake and Pistakee Lake larger. But it is the shallowest, with its deepest point only about six feet. The Fox River enters the lake on the west side and is the best spot for fishing on this lake. Lake Marie enters on the northeast side through a very long channel. It flows out through the large channel into both Fox Lake and Nippersink Lake. The channel splits around Crabapple Island with Fox Lake to the east and Nippersink Lake to the west. This island is the division between those two lakes and can be seen from the bridge on Grass Lake Road.

The lake is also the home of the famous lotus beds. These beautiful white flowers are Nymphaea-alba (the Egyptian white lotus.) People came from all over to view and take guided tours through the beds. The lake at one time was entirely covered by the lotus, with only a channel cut through for the tour boats. This species of lotus flowers is reported to be naturally found in only one other part of the world—the Nile River in Egypt. During the 1940s, a dam was built on the Fox River near McHenry. Water levels were forced to rise in the lakes. The lotus plants were pulled up by their roots from the lake bed and soon began to disappear. Visitors also picked the flowers and used the seed pods and bulbs for decoration. Soon it became almost impossible to find a lotus on the chain. But a few plants survived and are now protected by law. Boaters on the chain today can find small beds of lotus regaining space, especially in Grass Lake and Lake Marie.

When the lotus were plentiful, a perfume company from Chicago manufactured a perfume with the aroma of the plant. Resorts around the chain would purchase it and bottle it themselves. There are at least three bottles left! Two of which are on display at the Lakes Region Historical Society's School House Museum.

HOTEL BLARNEY. Blarney Island is a well-known establishment today, but before the dam was built it was attached to the land. Hotel Blarney sat on Whiskey Point and was accessed by a dirt road off of the main road (Route 173). Jack O'Connor was the proprietor and entertained his guests royally.

BLARNEY ISLAND, LATE 1960S. The party place to be, the island attracted boaters from all areas of the entire chain. Stopping for something to drink and a bite to eat was accessible from your boat. Later more piers were added to accommodate the numbers of boats that wanted to park.

VIEWING TOWER, 1935. This artist rendering of the lotus observation tower shows the density of the lotus flowers in the 1930s. The island was the destination for most of the touring boats. Guests could get refreshments and see the "sea of lotus" at the same time. The drawing did not exaggerate the abundance of the flowers.

CLOSE-UP VIEW, 1910. This close-up of a bunch of lotus was done by Lugar. Note his use of the copyright symbol. This was not on all of his cards, but most of his cards were numbered. This card is No. 425-A.

MIDWAY CHANNEL. This is how the boats would get through the large beds of lotus. A channel had been cut, and one can see Blarney Island at the end of the channel.

"WHERE WATERLILIES AND REFLECTIONS MEET." The designer of this card certainly had the appropriate caption. How wonderful to be in a position to see the tree reflections reaching toward the lotus. The image would only last for a short time, and people are fortunate to have this view today.

LOTUS IN FULL BLOOM. The picture speaks for itself. It is obvious why people wanted to take these beautiful flowers home with them. These beds had been here for hundreds of years or more, and it took man less than a half century to almost destroy them.

THINNING BEDS. Many of the lily pads are actually under the water instead of floating on top. This happened when the dam in McHenry was built. The water levels rose, and the plants were pulled up by the roots as the pads tried to stay above the water level.

The Boat Landing, Ray Pregenzer's Resort, Grass Lake, Antioch, Ill. 6709-nr

A BOAT LANDING AT RAY PREGENZER'S RESORT. This hotel catered to the hunter and was open late into the season. The rooms in the hotel were well warmed so the hunter returning from a day in the chilled air could warm up quickly and enjoy the evening with others staying at the hotel. In the summer, Ray ran the boat excursions to the lotus beds. Ray Pregenzer opened his resort in 1905 and he eventually sold his place to the Halings.

Lotus Flowers from Life, Ray Pregenzer's Resort, Grass Lake, Antioch, Ill.

LOTUS FLOWERS FROM LIFE. The lotus flower has been part of history almost from the dawn of time. It is revered in both the Buddhist and Hindu religions. Even Cleopatra loved the lotus flower. The rich aroma of the flowers was intoxicating and could be smelled everywhere on the lake.

H. Jackson. This is a good example of those folks that added on to the family home to create space for summer visitors. Most of these home resorts could only accommodate a small number of visitors. But the income helped the family make ends meet. It almost has the look of many of the new homes today.

A Morning's Catch at Jackson's, 1921. The fish in the chain were so abundant and large that a catch such as this could be seen at every resort in the area. Smell dinner sizzling on the stove or over an open fire. This catch would certainly be the envy of all the fishermen today.

Lotus Flowers at Hotel Blarney, Jack O'Connor's Place, Grass Lake, Antioch, Illinois

THE LOTUS BEDS. This is the view that one would see looking out across Grass Lake in the early days. Unless one knew better, it would seem that one might be able to just walk across.

Chas. F. Haling's Resort, Hunters and Fishermens' Headquarters on Grass Lake, Antioch, Ill.

HALING'S RESORT, 1926. C. Haling owned a tavern in the city from 1900 until 1920. He visited Pregenzer's and eventually bought the property next to him and opened his own resort. Although Haling's no longer has rooms to rent, it is one of the larger marinas in the area. It is also the host of many fishing tournaments. Chuck Hailing can remember bottling perfume as a child at his grandfather's place.

HALING'S RESORT, 1965. This 1965 view shows the growth and the numbers of boats that visit the marina on a daily basis during the summer season. The marina offers all the services that any boat owner needs.

BACK OF CARD ABOVE. Note the telephone number on the card. In 1965, they still did not have the seven-digit number (and now there are 10!) One could dock one's boat and have something to eat and drink while the mechanic on duty checked out the noise in the engine.

C. HALING and SONS
Dependable Sales and Service

JOHNSON MOTORS • LONE STAR
ALUMA CRAFT • PONTOON BOATS

Storage • Launching • Docking • Gas
Oil • Food • Bar • Marine Accessories

OPEN 7 DAYS A WEEK

Route 59 to Grass Lake Road —West on
Grass Lake Road to Haling Sign.
Rt. 1, Box 205 • Antioch, Ill.
Phones 2250 and 372

Hello to all.. out to the cottage & having a nice time. Lots of Green Beans & Picked a Pail of Tomatoes to day will write later & yours to fishing is Pertty good Love to all Paulina & Clarence

Rother's Resort, Grass Lake, Antioch, Ill. 6704-nr

ROTHER'S RESORT. Butch Rother was known for his experience in the area. Of course the summer months were the busiest, but Rother was an expert in hunting, and his place became known for the fall season as well. He would take guests out to the best spots for hunting all types of prey. In the summer, he ran a steamboat to the lotus beds.

View from Lawn showing Hotel and Dance Pavilion, Rother's Resort, Grass Lake, Antioch, Ill. 6701-nr

ROTHER'S DANCE PAVILION. In addition to the other services, Rother's Resort had one of the best dance pavilions on Grass Lake. This was a favorite destination year after year for many. It almost makes one want to travel back in time for a week of relaxation and fun.

PASKE'S LOTUS PARK RESORT ON GRASS LAKE ANTIOCH ILL

PASKE'S LOTUS PARK RESORT. What a beautiful sight! Note the channels cut from the lotus beds and how they resemble a roadway. These channels made boat trips much easier and provided a way through Grass Lake to the other lakes. Before man decided to traverse these beds, they stretched over the entire lake without any way through.

JIM HANRAHAN'S RESORT, EAST SHORE, GRASS LAKE, ANTIOCH, ILLINOIS

JIM HANRAHAN'S PLACE, 1935. Located on the east shore of Grass Lake, Jim Hanrahan's place offered food, drink, and a day's adventure. Tour boats to the lotus beds and fishing all along the chain were daily excursions from the piers of this little establishment. Note the open landscape. There appears to be a road at the top of the bluff, and perhaps the house behind is Hanrahan's home.

ENTRANCE TO SELTER'S RESORT. Robert Selter not only owned the wonderful resort, but he was also the owner of the Spring Well Bottling Works. That company manufactured high-grade carbonated beverages. He provided these drinks to many of the area resorts. Because of his devotion to the manufacturing company he decided to lease the resort to Charles Spring.

GOOD FISHING AT SELTER'S AND SPORTSMEN'S HOME. A stunning view of the shoreline near Selter's shows the reason why the fishing was so good. The fish certainly found this a paradise for themselves. It is no wonder that an experienced hotel man like Charles Spring wanted to be part of Selter's Resort.

SPRING'S HOTEL, 1908. The writing on the card reads, "Dear Sir; Ice is breaking, the ducks are beginning to fly. Water is high and sloughs are full." It is signed by C. M. Spring and addressed to B. Eastman in Chicago. Is this hotel part of Selter's Resort?

THROUGH LOTUS BEDS TO OTTO'S GRASS LAKE HOTEL, 1929. Looking closely at the edge of the lilies below the boat to the left, one of the lilies looks like a bird standing in the water. The imagination can find many things in the water.

"SHORTY'S," THE HEAD OF THE LOTUS BEDS. This is a rare card. The name on the building is printed in reverse. It actually says "Rohema," which is the name of the resort. Shorty's was well known in the area, and excursion boats came in and went out in rapid order.

WELCOME TO OUR LITTLE CITY, 1908. Shorty actually considered himself the mayor of the little city of Grass Lake. This appears to be his home built upon the water. It does have some foundation, and the far end is definitely supported by poles into the lake bottom. This would be a wonderful way to live. But when the lake levels rose, Shorty probably would have moved.

VIEW OF THE LOTUS FROM SHORTY'S. The lotus beds seem to stretch for miles. The boats would line up along the pier and load and unload passengers easily. It is very obvious here how low the lakes were before the dam was built. These piers would have been underwater after the dam backed up.

HEART O LAKES SUBDIVISION. One of those early subdivisions developed for the people who wanted to move to the area permanently, the Heart O Lakes Subdivision is still a very popular place to live. The larger lots were very desirable then as they are today. A channel runs along the south side, providing more water access to the homes.

KLONDIKE. This photograph is probably from the 1920s, as it is a ML photograph. The boats also have small motors for traveling around the lakes. They needed the long pier, as the area between the buildings and the boats was very swampy. The Klondike was located at the end of Grass Lake Road before the bridge was built.

LOG CABIN AT LOTUS INN. The cabin was located near Vineyard Point and was part of the Lotus Inn. It appears to be one of the earliest settler's cabins. Its location is a mystery, and it is doubtful that it still exists. What stories it must have had. It was surely home to a pioneer family.

LOTUS IN A VASE, 1908. The reverse of this card from Trevor, Wisconsin, September 11, 1908, reads, "How are all the folks? We have not had any rain for about a month and are pretty near burnt up. Murray." This is a very early photograph from Lugar. The beauty of these flowers has been preserved for all generations.

LOTUS BUDS FROM LIFE. The lotus began to open in the morning. The petals unfold and rise to meet the sun. Reaching toward the sun, they drink in the warmth and prepare for the day. When the evening comes, the petals close up and rest the night through, waiting for the sun to return.

GRASS LAKE BRIDGE. The bridge was finally built in 1942. Prior to this, one would have to drive a long way to get from Antioch to Fox Lake. At that time, these two towns were the largest and most important along the chain.

Seven

Fox Lake and Nippersink Lake

Fox Lake and Nippersink Lake together total over 2,120 acres. The deepest point is only 20 feet. The lakes are the busiest lakes on the chain in the summer. With the amount of boat traffic and the effects of the Fox River running through, the waters are almost always choppy once the boating season begins.

There are several inlets to the pair of lakes. Petite Lake enters at the northeast corner of Fox Lake, Grass Lake is on the north, and a small inlet from Squaw Creek is on the south side. There are also various small channels and creeks that flow into the lakes. The outlet for the lakes is into Pistakee Lake on the south end of Nippersink Lake.

Although Fox Lake had a slow start on the tourist trade, it made up for it as soon as the trains started running through it in 1900. The village is considered today to be the center of the chain. Route 12 running through the town and growing business and housing makes it a desirable area in which to live.

CUSHING'S RESORT, ALONG THE SHORE. Cushing's Resort, on the northeast shore of Fox Lake, offered the amenities that the vacationers were looking for. Boats were available for the guests' use, and there was a sandy area to get to those boats. The cottage in this picture was not part of Cushing's. According to the back of the card, it was Schaeffer's Cottage.

CUSHING'S RESORT, THE CANDY STORE, 1914. One of the favorite spots at Cushing's was the Candy Store. The two young girls are probably waiting patiently to get permission to go to the store. What little treasures could be found behind the door? Look very closely and see a horse and buggy on the left of the building.

THE DINING ROOM AT CUSHING'S RESORT, 1917. The dining room offered some of the best food around. And the tables were set up family style so all the guests would have the opportunity to meet others that were staying there at the same time. It was also a place for the locals to go for an evening out.

DON'S ON THE JOB, 1916. The impression given is that the dog's name is Don. He looks a little damp so perhaps his job was to flush out the ducks for the hunters. Or maybe he just wanted to take a swim. Either way, he is a beautiful dog.

ILLINOIS, THE HOTEL ON THE HILL, 1914. The Illinois Hotel sat high on a bluff overlooking Nippersink Lake. In this view, facing east, the rising sun casts long shadows from the trees. The three young ladies are out for a morning walk before breakfast. They must certainly be enjoying the cool breeze before the day gets too hot.

KING'S ISLAND. Since this is a boat landing, the assumption is that this group is either coming or going. There are a total of 21 people posing for this picture. Since there are men in suits and women and children and two men with large strings of fish, the photographer may have asked anyone there to pose for the picture. Hopefully they are not all going to try and get in the three boats!

HASTING'S BATHING BEACH, 1911. What a fun place to be. If one looks closely in the middle of the picture, there are two young gentlemen posing for this picture. The rest of the crowd does not seem to even notice the photographer. Note the building with the doors. That is where everyone changed clothes. No one would dare go to the beach already in their bathing dress.

HOMES ON INDIAN POINT. Indian Point is a tip of land on the northern shore of Fox Lake just outside of Columbia Bay between the channels leading back to Ackerman Island. There are still many homes at this point. One can see how thick the trees were back in the 1920s.

THE OTIS HOTEL. There is not a lot known about the Otis Hotel. This card shows a large building in the background with rows of trees. The pole at the front is probably close to the water's edge so that boaters coming ashore would be able to identify where they were.

BOAT LANDING AT THE OTIS HOTEL, 1921. These gentlemen and lady appear to be just enjoying a quiet afternoon. Others on the pier are getting into a boat. Perhaps they were preparing to visit the lotus or do a little fishing. Obviously they had no comfortable lawn chairs. One from the dining room worked fine.

GROUNDS OF THE OTIS HOTEL. The Otis Hotel was on the north end of Fox Lake. So was the Cushing Hotel. Look closely at this picture and the one of the candy store at Cushing's. The building has a similarity, and the trees are in the same straight line. Is it possible that Cushing's and Otis are one and the same?

LAKESIDE HOTEL, 1911. There was a Lakeside Hotel on Fox Lake and another one on Pistakee Lake. Even though the card says Fox Lake, this one still could have been the one on Pistakee Lake. There were really only two places that got mail during this time and it was Antioch and Fox Lake. The sign to the right of the picture does say Lakeside Hotel.

POINT COMFORT HOTEL AND COTTAGES, 1919. The sign over the door clearly lets one know that one has arrived at Point Comfort Hotel. The veranda is lined with chairs and rockers and appears to be full. Others just sit on the lawn. It looks like a full house. Everyone is resting for a big night down at the pavilion.

BATHING AT POINT COMFORT. The bathing beach here appears to be rather shallow and can accommodate a large number of people. This is the only way to spend a hot afternoon. Is that person in the front waving to the photographer or just protecting their eyes from the sun?

POINT COMFORT PAVILION. The Point Comfort Pavilion also served ice cream, candy, and soft drinks. There were plenty of boats for the patrons, and note that there are some automobiles parked nearby. As the automobile became more popular, the patrons abandoned the trains.

BEFORE THE RACES, 1932. Boat races were a favorite activity for those who owned sailboats. Because Fox Lake is one of the larger lakes, it is perfect for the sailboats. When the boats would race, there were usually many people from the local area that would come and watch. People still flock to the boat races on Grass Lake.

THE LIPPINCOTT HOTEL. The Lippincott Hotel was on Lippincott Point in Mineola Bay. Most buildings were constructed of wood and would not last long. Many of the original buildings no longer exist unless at some point they were renovated. The dance pavilions were built for only summer weather. When a good storm came through many of these buildings were damaged.

TOMBOY, PARKED AT THE LIPPINCOTT HOTEL LANDING. The boat parked at the dock was called *Tomboy*. The name appears on the bow of the boat. It was designed for excursions on the lakes, especially for trips to the lotus beds. This boat could handle at least 20–30 people. The roof of the boat would protect its riders from the sun.

CRAB APPLE ISLAND. Crab Apple Island divides the two lakes, Fox and Nippersink. It is not the first chunk of land that can be seen from the Grass Lake Bridge but is actually about a half mile south of that bridge. One side of the island can be seen. Without the island the two lakes would be one.

SHAW'S SUBDIVISION. This subdivision was near the Cushing Hotel. These houses were set high on the bluff and back from the edge of the water. After the dam was built in McHenry, these homes were much closer to the edge. Many of these homes still stand along the shore and have been renovated with modern amenities.

THE MINEOLA, 1914. The Mineola is probably the best-known resort. It still stands proudly on the shoreline of Fox Lake. Like a regal queen, it ruled for many years. Although getting older and out of shape, there is still a magic about it. The ballroom has been renovated and is host to weddings and other events. The downstairs bar and restaurant offers a fantastic view of the water.

THE FOX LAKE YACHT CLUB. This view was probably photographed in the early spring before the crowds began to arrive for the season. The choppy water from the spring thaw would have damaged the boats. Later in the season, this pier would have been lined with sailboats and maybe a new motorboat.

Eight

Pistakee Lake

Pistakee Lake is a medium-sized lake with 1,700 acres. It is approximately 31 feet deep. The inlets to this lake are from the Fox and Nippersink Lakes on the north side. Its outlet is the Fox River on the western shore. Following the Fox River will take one into McHenry. There is also a small lake to the southeast called Redhead Lake. Some people consider this another lake in the chain although it is quite small. Early maps spelled the name of this lake as Pistaqua.

Part of Pistakee Lake lies in McHenry County. In 1837, Brown's Inn in McHenry was the first inn to be built on the chain. The trains started in 1854, and so McHenry lays claim to the first real activity on the lake. In 1875, the Riverside Hotel was built on the Fox River, and by 1883, cottages began appearing on Pistakee Lake.

By 1883, upscale cottages began to appear along the shores of Pistakee Lake. It became the home of many hunting clubs and upper-class resorts. From 1905 through 1923, speedboat races were held on the lake. Many new improvements for these racing boats were inspired by these races. August 1912 found more than 42 boats in the races, with over 1,500 spectators. The races would usually run every other week during the summer months.

HOTEL HELVETIA, 1932. The Hotel Helvetia is actually located on Pistakee Lake. It was open all year when many others closed for the winter. The hotel's kitchen prepared home-cooked food that many of the locals also enjoyed. There was a wonderful beach for swimming and plenty of motorboats for the guests.

BOAT LANDING AT PISTAKEE STATION, 1915. Pistakee Station was one of the more popular locations to board the excursion boats to the lotus beds. The Illinois Hotel on Nippersink Lake can be seen in the background. There is a channel running between the Nippersink and Pistakee Lakes.

JENSEN'S LANDING, 1929. Located at the end of Main Street, this small landing served many of the residents in the area. This couple was probably out for an afternoon stroll and ended up at the pier. The little baby seems to be enjoying herself, and the ice-cream parlor has seen better days.

NOTTER'S HOTEL, 1923. This group of young people is getting ready for a great afternoon. An airplane can be seen at the right of the picture. This would be unusual even today. It would have been exciting to take a ride and see the lakes from the air.

FRITZ MINERAL SPRINGS HOTEL, 1914. The children in this photograph are having a cool drink from a natural spring. Although most of the lakes are glacier made and the Fox River flows through, there are many natural springs in the area. Many of the ponds and smaller lakes are actually spring fed.

PISTAKEE YACHT CLUB IN PISTAKEE BAY, 1925. The large boat in front was named *Doctors*. It looks like everyone who wanted a ride would bring their own chair aboard. This card was actually printed in Fox Lake, rather than Chicago or Germany where so many of the early postcards came from.

EAGLE POINT REST, 1922. Eagle Point Rest, even the name makes one want to take a vacation to rest, and stay in the house up on the hill and enjoy an ice cream when returning from a calm boat ride. When it was time to go home one would not want to leave.

OAK PARK HOTEL, 1908. This is another home that was turned into a resort. Perhaps the name came from the owner's former hometown. Or maybe from the beautiful oak trees that surrounded the building. And who is Rosebud?

CORBETT'S PAVILION AND BUFFET, 1915. A celebration was taking place here. It is unknown what it was, but all the ladies appear to have the same type of hat, and they are holding a banner that says "Fox Lake." As a buffet house, Corbett's would have been able to provide the food for a group this large.

PISTAKEE BEACH HOTEL, 1916. The postage date on this card is September 4. This would have been a time when most guests would leave for home. School would be starting, and the weather would start to get cool. There was one more season when guests would come back. During the brisk fall, the hunters would come north for one more trip.

Nine

Loon Lake

Although Loon Lake is not part of the Chain O' Lakes, it is a wonderful lake for all the summer events. It is just south of, but part of, the town of Antioch. The area around the lake is mostly private, and the residents have a normally quiet life. Unless of course they live on the west side alongside the railroad tracks.

There are actually two different lakes that are connected by a channel. Most maps will show them as Loon Lake and East Loon Lake. Often they are referred to as East and West. The Loon Lake area is bordered by Route 173 to the north, Route 83 to the west, Grass Lake Road to the south, and Deep Lake Road to the east. The area is part of Antioch, and when Antioch incorporated in 1892, the first elections were held at Thomas Warner's place on Loon Lake. It was considered the center of the township.

By 1839, cabins had been built along the shores of Loon Lake. It has a creek running from it to Lake Marie. Sequoit Creek was a large creek then, but today it has very little water and some of it runs underground through Antioch. It was home to the first sawmill, and the creek provided the power to operate the paddle wheel. The Hiram Buttrick Sawmill was recreated in Antioch in the 1970s and is a local historical site.

ENTRANCE TO CAMP CHI. Camp Chi was for young ladies during the 1930s. This entrance, made of rocks, would continue to stand for decades. The wide-open spaces made for a perfect setting for a summer camp.

MAIN STREET AT CAMP CHI, 1937. The young ladies enjoyed their time at the camp. The cabins were lined up along Main Street, and people would have to remember which of these cabins was theirs.

CAMP CHI BATHING BEAUTIES. As with any summer camp, the hot afternoons were spent in the water cooling off. This was one group of campers that was definitely having a good time. Cold and rainy afternoons could be very long. Recognize anyone?

ENTRANCE TO MOODY BIBLE CAMP, 1963. If this looks familiar, look at the entrance to Camp Chi. Sometime between the 1930s and the 1960s, the camp became the property of the Moody Memorial Church. It offered young people a "God-centered," unique camping experience.

VILLA RICA ENTRANCE, 1944. Villa Rica is a private subdivision on the south side of West Loon Lake. Access is from Grass Lake Road east of Route 83. There is no outlet. Most of the roads that go into the Loon Lake area are dead ends.

BEACH SCENE AT VILLA RICA. The postmark date on this is covered over, but this scene is from the 1940s. This was a typical scene in the summer. It was published by Dickey Photo Service in Waukegan.

FISHING PARTY AT SETEK'S RESORT, 1923. This Lugar photograph shows how large this lake really is. These twin lakes were certainly carved out at the same time as the chain and could have easily been part of it. The distance to one of the lakes was too far to carve a channel in the early 1900s, so it was left on its own.

SETEK'S RESORT, 1923. Setek's was a rustic fishing and hunting resort. Some of these buildings are still standing today. This view looks like it may have been taken on a misty morning as the sun was coming up. Although very hard to see, in the right center of the photograph, on the porch, sits a family.

THE MILLIONAIRES CLUB. Were these people really millionaires? Or was this the staff of the club? Whether millionaires or not, they were able to enjoy the same beautiful land as everyone else. Nature is the same for everyone.

THE LAKE VIEW HOTEL. This hotel was a private home at first. When the boom began, the family added on to provide a place to stay for vacation. This type of hotel always seemed to be the best. Guests were provided with home cooking and attention from the family.

BELLEVIEW CLUB, 1929. Sometimes a large family group might build a summer house by the lakes. This way the different parts of the family could gather during the summer and share times together. Perhaps others would be invited to participate, and the groups would continue to grow. This would assure that there was always a place to stay.

CAMP FOUNTAIN, 1914. This tent city is on the banks of Loon Lake. It looks to be semipermanent, and yet some of the gentlemen are dressed very neatly. Could this have been a military camp? The writer wrote on June 17, "arrived safe and this is the place I am staying at, will notify you when I will leave. Paul."

JOLLY JOSEPH'S SOCIAL CLUB. Just the name makes one want to party. This would be the road side of the club. At the top of the picture one can see electric lines, so it seems this club was closer to the main roads and able to get electricity in for the guests' pleasure.

JOLLY JOSEPH'S BATHING BEAUTIES, 1926. Look at those bathing suits. They were very fashionable for their day. The 1920s brought change to the way women dressed and behaved. Women were given the right to vote in 1920, and thus a new era began.

SHADY LANE. Shady Lane is another subdivision on the south end of Loon Lake. The signs on either side of the arch seem to give the names of the residents of Shady Lane. By working together as a group they were able to maintain a beach area for everyone's use.

HULIC'S RESORT. Joe Hulic, proprietor of this resort, cared for his summer guests in a very efficient manner. He provided boats, bait, and fishing tackle for an enjoyable experience. The main building is a little different than most, as one can walk straight through from the road side to the lake side.

THE NORTH SHORE, 1908. The north end of the lake was rather barren in the early days. There is a residence, perhaps one that had been there for many years. This may have been the location of one of the earliest cabins. A home, a barn, and the most important, an outhouse! What more could a person want?

AN ICEHOUSE, 1915. One of the main winter activities in the entire Chain O' Lakes Region was the cutting of ice. When the ice would reach 10 to 12 inches, the men would start cutting. It was not an easy job. The large ice blocks would be stored in icehouses to be used during the summer months.

COTTAGE POINT, 1924. Although there is no indication where Cottage Point was on Loon Lake, there is one place on the north shore that could be considered a point. The early cottages were probably some of the first to be built. An advertisement in the advertising book from Antioch Lumber and Coal Company was giving estimates and building these cottages.

THE ISLAND, 1925. This is only one location at the north end of East Loon Lake that might possibly be considered an island. All of today's maps do not show any island on either lake. Land does continually shift, so perhaps a land bridge developed over the years and connected one end of the island to the main land.

THE CROSSING, 1909. This artist's rendition of the train crossing at Loon Lake has a bit of humor. "Look out for the cars." Perhaps the sign actually existed. Is the sign for the train or the automobiles of the day?

THE TRAIN, 1910. A passenger train traveling south is likely carrying many people headed home on a Sunday afternoon. Will the train see the sign at the Loon Lake crossing?

Ten

Other Lakes

There are many other lakes in Lake County that play an important role in the tourism of the area. Many of the lakes never had postcards made of them, but they still deserve mention. Cedar Lake is a 300-acre glacial lake with a maximum depth of 44 feet. It is the fourth deepest in Lake County and is located in Lake Villa. Cedar Lake has a large island in the middle that is the subject of many stories. Crooked Lake is in Lindenhurst to the east of Deep Lake. Cross Lake is located north of Antioch in the subdivision of Oakwood Knolls. The lake actually is in both Illinois and Wisconsin. Deep Lake is directly east of Lake Villa and slightly smaller than Cedar Lake. It has a smaller lake, Sun Lake, which is connected to it on the northwest side by a small creek. Hastings Lake is in Lake Villa on Grass Lake Road. Silver Lake is east of Antioch and north of Loon Lake. It is most easily accessed from Route 173 or Depot Street.

Other lakes in the area include Antioch Lake; Turner Lake, located in Chain O' Lakes State Park; Mud Lake, also located in Chain O' Lakes State Park; Spring Lake, on the channel between Bluff Lake and Petite Lake; Waterford Lake in Lindenhurst; Linden Lake and Lake Potomac, both near Waterford Lake; Sand Lake, Slough Lake, and Miltmore Lake in the Lake Villa area; Fourth Lake, Third Lake, and Druce Lake, in the area of Route 45 and Washington Street; Round Lake, Highland Lake, and Cranberry Lake in the Round Lake area; Grayslake in Grayslake; Redhead Lake and Brandenburg Lake, south of and connected to Fox Lake; Wooster Lake, Ingleside; and Duck Lake.

School House, Chapel, & Gymnasium.
Allendale Farm, Lake Villa, Ill.

ALLENDALE FARM, LAKE VILLA. Allendale began as a school and residence for troubled boys and eventually housed both boys and girls. It serves a community of need and is located on Cedar Lake off Grand Avenue (Route 32) in Lake Villa.

LAKE VIEW OF ALLENDALE. Although not a resort, Allendale has stood as a source of hope for many children. The beautiful lake view and wooded lands have a calming effect on anyone. The builders of this school must have been impressed with the beauty of the area.

THE LAKE VILLA HOTEL, 1912. E. J. Lehmann, famous for his development of Lake Villa, built this hotel in the late 1880s. Right on Cedar Lake, it was the most popular resort in that area. It was originally called the Lake City Hotel. An 1885 advertisement tells of two other Lake City Hotels, one in Gurnee and one in Fox Lake. All were connected by a stagecoach line that belonged to Lehmann.

SHERWOOD PARK. A very popular public beach, Sherwood Park remained open until the late 1900s. Large sprawling lawns with lots of trees made for a perfect picnic afternoon and wonderful swimming at the beachfront. Many families would spend every Sunday during the summer at Sherwood Park.

VIEW OF CEDAR LAKE, OCTOBER 1912. This artist concept of Cedar Lake is so calming. The lake is usually quiet, even today. The writer of this card, Ed, is sending a note to his "home folks." The weather was fine for outside work, and he hoped it would last until Christmas.

ANOTHER VIEW OF CEDAR LAKE, OCTOBER 1926. Ed wrote another card to the home folks, telling them that he was finally getting some sunny weather and would be going to work at Weler's. The earlier card was addressed to Myrtle Millington in Mansfield, Ohio, and this later card was to L. T. Millington, also in Mansfield.

DUKE'S RESORT. This resort was located on Little Silver Lake. The address is shown as Antioch, Illinois, but Little Silver Lake is located in Wisconsin. There is a Silver Lake in Illinois north of East Loon Lake and also north of Route 173. Silver Lake is not connected to the other lakes.

SCENE AT SAM SORENSEN'S, 1925. This scene is on Silver Lake in Illinois. This lake did not have a lot of development. There has been building around it that has not been without its problems but has added to the population of Antioch. This scene may have been a boating class from a camp in the area. The card is written in German.

HENNING JOHNSON'S RESORT. Located on Deep Lake in Lake Villa, Johnson's Resort offered all the activities that any good resort would offer its guests. There were plenty of boats available. From the bathing suits worn by the young ladies, this was probably in the 1940s.

JACKSON'S RESORT. This image of the resort on Deep Lake appears to be from the second or third decade of the 20th century. It was probably a private home before being turned into a resort. So many of these resorts have no other available history that one can only guess what they were like.

KRAL'S HILLSIDE RESORT. Even though Deep Lake was not on the Chain O' Lakes, it was still a very popular lake. This resort looks like it would have been delightful to stay in. Nestled in the trees, high above the lake, the view must have been tremendous.

SCENE AT OAK VILLA, DEEP LAKE, 1923. The writer of this card wrote home to tell the family that he had learned how to swim on his back and row a boat. He also took a motor trip to Zion City. He was writing from "The Highlands." Perhaps the resort had changed names, or he was staying somewhere else.

SCENE ON DEEP LAKE, 1911. This card is by the same writer as the two Cedar Lake cards, Ed. It is addressed to Myrtle Millington. It is dated August 11, 1911. Ed let them know that there had been a hard thunderstorm the night before. The authors believe that Ed was probably Myrtle's son.

DEEP LAKE, LAKE VILLA, 1910. This one, also from Ed, was addressed to Myrtle on September 29, 1910. He was sorry that he had not written but said he had nothing to write. Myrtle had a birthday that he missed. Who Ed was is a mystery that may never be solved.

SUNFLOWER CAMP ON DEEP LAKE. Canoeing on the lake was a popular pastime in the late 1890s and early 1900s. The age before motorboats was peaceful and calm. One can imagine the early Native Americans doing the very same thing.

TEGAN'S RESORT. This resort was one of the earlier resorts. Probably a family home first, it was opened to visitors. Not being on the chain itself, it may not have been successful. Note that most of these pictures have people in them. The photographers were mindful of the importance of people in postcards.

VIEW FROM PIER. The pier is located by the Crooked Lake Oaks. Crooked Lake is located directly east from Deep Lake. This picture appears to be from the 1950s. Crooked Lake is actually in Lindenhurst.

A SCENE AT DUCK LAKE, 1939. Duck Lake is in Ingleside, near Fox Lake. It is south of Rollins Road, east of Route 59, and north of Route 132. It is an odd-shaped lake with many channels that do not connect with any other lake.

WOOSTER LAKE, INGLESIDE, 1931. This is McCarthy and Obermeyer Cottages on the shores of Wooster Lake. The lake is located directly south of Duck Lake and has a very even shoreline.

CAMP ROGERS PARK, 1944. This shot was taken from the diving pier in Hastings Lake. The writer of this card is telling a friend about her experience. She is a camp counselor and having a great time. Hasting Lake is located in Lake Villa east of Crooked Lake. The location today is in Lindenhurst.

THE BEACH AT CROSS LAKE, 1948. Cross Lake is the only lake in this book that is partially in Wisconsin. The card was published by Ted's Sweet Shop, a very popular shop in Antioch. He would use these cards for advertising.

GREETINGS FROM CROSS LAKE, 1947. This is "the view one sees through the trees." The lake is indeed a beautiful one, although a small one. This card was printed in Milwaukee, Wisconsin, in natural color.

CROSS LAKE. This is a Lugar photograph, No. 236. It was done in the early 1900s before the lake had become settled. Very few cabins were around the shore, and only fishermen frequented the lake. The young person in the boat has his pole ready to go.

VISTA OF CROSS LAKE, 1937. This shot is from the east side of the lake looking towards the early setting sun. This is a beautiful lake and has remained quite the same with only a few residences having access. The writer of this card is telling her friend that she is getting sunburned and all she does is sleep, eat, and swim. Now that's a vacation!

LONG LAKE, INGLESIDE. The lake is located in Ingleside, south of Rollins Road, west of Fairfield Road, and north of Route 134. The lake is quite large and well populated all around and is approximately the same size as Channel Lake in the upper chain. This is an early picture of the Stanton House.

LONG LAKE. This shot is looking north toward the point. There is a large point of land that extends out into the lake on the south side and two points on the north side. The X marks the spot that the writer talks about.

CAMP IDLE HOUR. The writer is having a great time at one of the camping grounds on the chain. With a bit of humor he writes on the tent that "here is our home." Another one of these cards was found with no writing on it, so it seems that it was very common to add private messages to them.

WOODCREST CHANNEL. These small channels are on many of the lakes. Some of them connect one area to another, and others are dead ends. They are favorite fishing spots even today.

VIEW THROUGH THE TREES, 1910. This was a very common scene in the early 1900s, long before the trees and bushes along the shoreline were taken down to make lake access easier.

DRIVE TO SUNSET VILLA. Dirt roads were the norm to all of the resorts in the early days. Many resorts were at the end of these roads. Look closely to the top of the hill. There is a horse and buggy coming.

SAILING ON THE LAKES. Sailboats were an everyday sight in the early days on the lakes. An occasional motorboat would be seen, making loud noises and disturbing the quiet lake.

THE LAKES IN THE 1960s. By the 1960s, a sailboat was seldom seen. Racing boats were the norm. By the year 2000, weekends on the chain had become so crowded that the common saying is now "you could walk across the lakes on the boats."

THE FISH FROM THE LAKES. This artist's rendition may not just be his imagination. There were many reports of very large fish living in the waters of the chain. Until the white man moved into the area, only the Native Americans fished. The fish had a good life.

THE BIG ONE. This actual photograph shows how large the fish could be. Maybe it was not as large as the artist's imagination, but this fish was big. It surely made a meal for several people—or a wonderful trophy for over the fireplace.

THE SCHOOL HOUSE, 1906. This is the schoolhouse built in 1892 in Antioch. It was no longer used as a school by the 1970s and sat empty for several years. In 1973, a group of dedicated people formed the Lakes Region Historical Society in order to preserve the history of the region. They held their meetings at the local library. In 1981, the school district leased the building to the historical society and renovations began. By 1987, the first floor of the building had been fully renovated and was dedicated. Today all three floors have been turned into a museum with artifacts of the lakes region. This book is sponsored by the Lakes Region Historical Society, and all profits realized are donated to them.

ACROSS AMERICA, PEOPLE ARE DISCOVERING
SOMETHING WONDERFUL. *THEIR HERITAGE.*

Arcadia Publishing is the leading local history publisher in the United States. With more than 3,000 titles in print and hundreds of new titles released every year, Arcadia has extensive specialized experience chronicling the history of communities and celebrating America's hidden stories, bringing to life the people, places, and events from the past. To discover the history of other communities across the nation, please visit:

www.arcadiapublishing.com

Customized search tools allow you to find regional history books about the town where you grew up, the cities where your friends and family live, the town where your parents met, or even that retirement spot you've been dreaming about.